WISDOM OF THE PLAIN FOLK

WISDOM OF THE
PLAIN FOLK

*Songs and Prayers from
the Amish and Mennonites*

*Compiled by Donna Leahy
Photographs by Robert Leahy*

Penguin Studio

PENGUIN STUDIO
Published by the Penguin Group
Penguin Books USA Inc., 375 Hudson Street, New York, New York 10014, U.S.A.
Penguin Books Ltd, 27 Wrights Lane, London W8 5TZ, England
Penguin Books Australia Ltd, Ringwood, Victoria, Australia
Penguin Books Canada Ltd, 10 Alcorn Avenue, Toronto, Ontario, Canada M4V 3B2
Penguin Books (N.Z.) Ltd, 182–190 Wairau Road, Auckland 10, New Zealand

Penguin Books Ltd, Registered Offices:
Harmondsworth, Middlesex, England

First published in 1997 by Penguin Studio,
an imprint of Penguin Books USA Inc.

1 3 5 7 9 10 8 6 4 2

5·20·01 12.95

Copyright © Donna Leahy and Robert Leahy, 1997
All rights reserved

LIBRARY OF CONGRESS CATALOGING IN PUBLICATION DATA
Leahy, Donna.
Wisdom of the Plain folk: songs and prayers from the Amish and Mennonites /
Donna Leahy; photographs by Robert Leahy.
p. cm.
ISBN 0-670-87180-X
1. Meditations. 2. Plain People—Pennsylvania—Lancaster County.
3. Lancaster County (Pa.)—Religious life and customs. I. Title.
BV4832.2.L38 1997
242'.809774815—dc20 96-30251

Printed in Singapore
Set in Matrix
Designed by Jaye Zimet

PHOTOGRAPHER'S DEDICATION

In appreciation to our Plain neighbors
for their generosity in affording me a window
to their remarkable culture,
which cherishes the glories of nature
and the rewards of hard work.

PHOTOGRAPHER'S
ACKNOWLEDGMENTS

I would like to thank with great love Donna Leahy, my wife, and the person who taught me that details are everything. It is her support and encouragement that have helped me to always "create" a photograph and not to be satisfied with merely "taking" a picture. I would also like to extend a special thanks to Dan Green, a man of few words, who has guided us through the maze called publication; to Cathy Hemmings for her support and expertise and for her special appreciation of the nuances of life in Lancaster County; to Erin Boyle for her keen and creative eye, her enthusiasm, and her organizational efforts to keep things moving along; to the Lancaster County Historical Society and the Lancaster Mennonite Historical Society for their fine collections; and to all our special guests at the Inn at Twin Linden who have shared in our lives in Lancaster County and enthusiastically supported our creative efforts.

INTRODUCTION

Our arrival in Lancaster County, home of Pennsylvania's Plain folk, was part of our personal search for a peaceful, scenic location in which to open a country inn. My husband, Bob, and I moved to the eastern part of the county in 1987 after purchasing a historic estate home, Twin Linden, in a small town overlooking Amish and Mennonite farm valleys. We felt accepted into the local community almost immediately, but it was a Plain woman who lived across the street who first extended a warm welcome by bringing over just-baked cookies on the very night we moved in. We felt as if we had really come "home." As we began the work of restoring Twin Linden ourselves, our new Plain neighbors would stop by and check on our progress. They appreciated how hard we were working, whether we were doing the mundane job of scraping paint or the daunting task of planting gardens where none had existed before.

In his work as an experienced underwater photographer, Bob had concentrated on capturing the inherent beauty of underwater life, rather than taking the more common documentary approach. His expertise had earned him a national reputation, and his above- and below-water photographs were published in a vast array of national publications. As soon as we moved to Lancaster County, Bob began photographing the area, captivated by its scenic beauty and bucolic settings. He respected the Plain People's rejection of photography for their own use and never took a photo that he believed would offend them. Seeing Bob traveling the back roads with all his gear, the local Plain People began referring to him simply as "the Photographer." Sometimes a farmer would stop his work to chat briefly with Bob while he photographed a barn or perhaps some horses. Eventually Bob received invitations to come inside, perhaps to witness the birthing of a calf or to see the beautiful quilt a Plain woman might be sewing. His sincere interest in their culture and traditional lifestyle evoked a warm response from the Plain People. They seemed to want to talk about their way of life, as if by telling him their stories and having him photograph their farms and homes they

would somehow further preserve it against the encroachment of modern society.

Finally, when our newly renovated inn was ready to open for business in 1990, we invited our neighbors for a house tour and celebration as a gesture of appreciation. Since Bob's photographs of the area decorate the walls of the inn, we were uncertain how the local Plain People would react to seeing their farms and homes displayed in such a public place. To our delight, their reaction was overwhelmingly positive. His respect for their beliefs and his eye for the natural grace in simple things had struck an accepting chord in the Plain community. Over the years, this acceptance among the local Plain People has given him a unique access and an ability to expand his work beyond scenic vistas to capture the serenity and joyfulness of their lives in a more personal way. Our life in Lancaster County is inextricably woven into the fabric of the Plain culture.

To understand the culture of the Plain People is to appreciate how much modernization can take us away from life's simple pleasures; the Plain People flourish in today's world without the benefits of modern conveniences. They are a gentle

group who cherish the glories of nature and the rewards of hard work. Their social structure is a tightly knit community whose members depend on each other for social interaction as well as religious strength and continuity. Home is the center of the Plain society, the place where family members enjoy a secure niche in their family's work and play. Above all, the Plain folk believe in simplicity as a means to achieving a higher spiritual end.

The designation "Plain" most likely originates from the Amish and Mennonite style of dress, which reflects the desire to express modesty and reject pride. Because much of the Amish culture is not retained in written form, members depend on oral tradition to dictate the boundaries of dress. These standards are dictated in the ordnung, the unwritten rules of each church district. While Mennonite dress codes are generally less strict than those of the Amish, the most traditional group of Mennonites, the Old Order Mennonites, also adheres to a stringent code. In its strictest interpretation, the Plain style of dress excludes any item perceived to be a decoration or any feature that would differentiate one individual from the group. The Plain dress maintains the cultural iden-

tity of the group and promotes cohesiveness in the social structure.

The Plain People trace their history to the Swiss Anabaptists, a group of Protestants who, in the sixteenth century, believed that baptism should be bestowed only on adults who could make a commitment to their faith. The Anabaptists wanted more far-reaching changes than those proposed by Protestant Reformers such as Martin Luther and John Calvin. They rejected the outward symbols of religion, including the observance of mass and the church hierarchy, and refused any alliance between their own religious group and the political establishment. The Anabaptists were perceived as a threat to civil authority and were harshly persecuted for their beliefs. One of the most influential leaders of the Anabaptist movement was a former Catholic priest named Menno Simons, whose followers came to be known as Mennonites. More than a hundred years later, in the late seventeenth century, a young Anabaptist leader named Jacob Amman emerged in Alsace, now in northeastern France, where many Anabaptists had fled to escape persecution. He promoted a more disciplined lifestyle for his followers, including meidung, the prac-

tice of shunning expelled church members in all social contexts. The division of this more conservative group, known as the Amish, from the Mennonites continues today, as evidenced in each group's distinctive style of dress and varying degrees of worldliness. Escaping from religious persecution, the Amish and the Mennonites arrived in Lancaster County in the early 1700s at the invitation of William Penn.

Today the Anabaptists consist of three groups—the Amish, the Mennonites, and the Brethren. The differences between them lie primarily in their biblical interpretations and the degree to which modern technology is allowed to influence their lives. While many beliefs are shared among the Plain People, the Mennonites and the Brethren are generally more willing to accept technology and higher education in varying degrees than are the Old Order Mennonites and the Amish.

The Amish believe that pride is a threat to community welfare and therefore disallow credit for any accomplishments. For this reason, the writings of the Amish are generally not ascribed to any particular individual. This rejection of public recognition includes their aversion to photography, which might promote self-aggrandizement, and the simplicity of

their dress. Work is important in maintaining both the Amish and the Mennonite cultures because it represents the contribution and commitment to the community.

Regular Amish church services are held every other Sunday in one of the households that make up the church district; Amish children attend school up to eighth grade. Mennonites meet in community meeting houses, and their children sometimes continue on to higher education. The bishop is the leader of the church district, but ministers also preach at the services. All baptized members of the church, including women, participate in the selection of the church leaders. Women are not, however, eligible to be church leaders. Plain women assume a traditional role in marriage: caring for the children, managing the household, making clothes for the family, preparing the food, and gardening. Farming is the primary occupation of the Plain People and their ties to the land contribute to maintaining their religious identity. Quilting is a community effort for which both Amish and Mennonites are well known. Although quilting was actually adopted from English neighbors in the nineteenth century, it is an efficient way to make use of scraps of material and has become a per-

manent part of the Plain culture. The use of horse-drawn buggies by the Amish and Older Order Mennonites keeps them close to home and maintains their separation from the mainstream of society. The key to maintaining the Plain culture has been the encouragement of social networking within the group. While some young members choose to leave the Plain community in pursuit of greater economic rewards, the Plain population overall continues to grow.

The Plain culture is one that rejoices in the simplicity of nature, the values of family life, and the change of the seasons. Children work with parents to prepare and maintain the family's garden, which provides a layer of independence from the outside world. The land is often worked by hand or with horse-drawn equipment, again reaffirming the slower pace of their lifestyle and its close ties to nature. Quilting mirrors the essence of the Plain lifestyle: a quilt may be a thing of beauty to an outsider, but to the Plain People it promotes a utilitarian recycling of material and encourages community and craftsmanship.

The Plain People may enchant us with their stoic attire and horse-drawn buggies, but perhaps we are most enamored

with the simplicity of their lives and their ability to withstand society's constant pressures to conform. The opportunity to live in Lancaster County has afforded us a personal perspective on the cohesiveness and serenity of the Plain culture and the intrusive forces of development and modernism that threaten its very essence. The writings of the Plain People reflect the basic desires in all of us: to be good to our fellow man, to leave the world a better place than we found it, and to find happiness in our family life. The simple meditations, prayers, and songs of the Plain People offer an insight into their culture that is an inspiration in our daily lives as well.

LIKE ANGELS' SONGS

Adoring angels turned their songs
To hail the joyful day
With rapture, then, let mortal tongues
Their grateful worship pay.

—Amish hymn

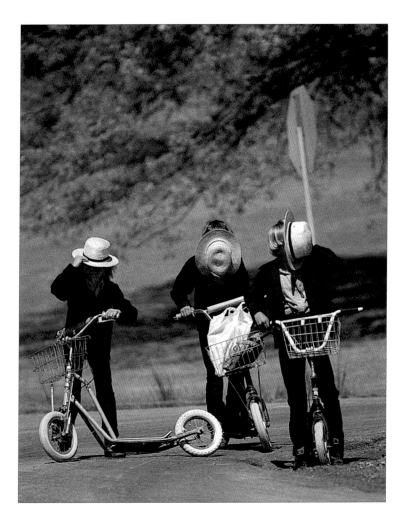

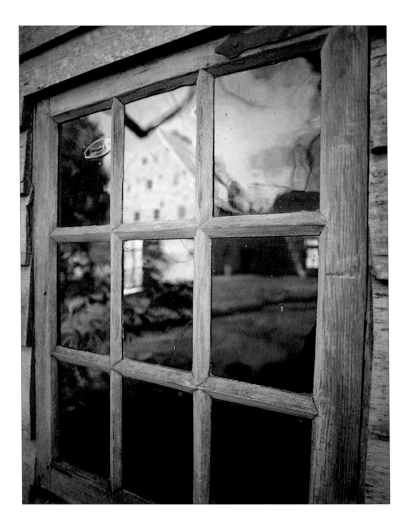

Do good and leave behind you

a monument of virtue

the storms of time can never destroy.

—*Early Mennonite proverb*

Be friendly to all and a burden to no one.

Let your manner be courteous, your forgiveness

willing, your promises true, and your speech wise.

—*Amish proverb*

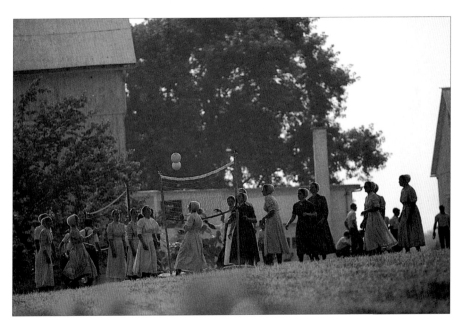

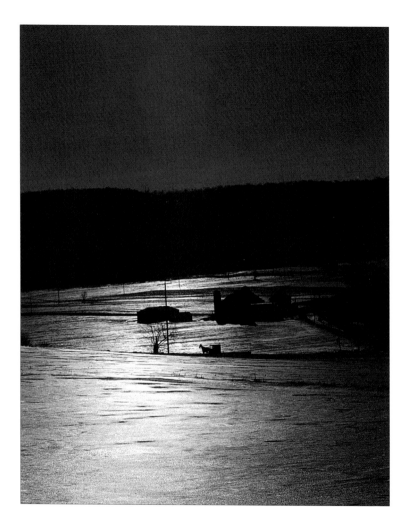

AT DAY'S END

I love to steal awhile away
From every cumb'ring care
And spend the hours of setting day
In humble grateful prayer

Thus when life's toilsome day is o'er
May its departing ray
Be calm as this impressive hour
And lead to endless day.

—*Mennonite song*

Appetite comes with eating;

the more you eat, the more you want.

—*Amish farmer's proverb*

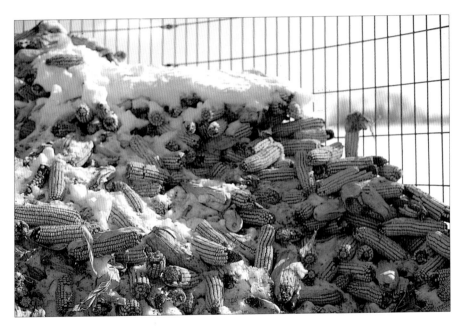

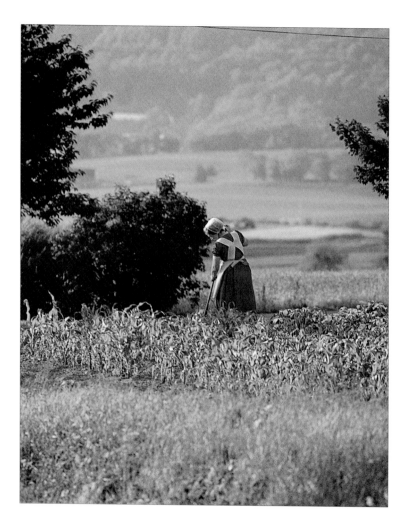

GARDENER'S HYMN

Bid the refreshing north wind wake
Say to the south wind blow
let ev'ry plant the pow'r partake
and all the garden grow.

—Amish hymn

ON FORGIVENESS

If anyone wrongs you, exercise forgiveness
and patiently dismiss the matter.
For if you take the wrong to heart,
you hurt no one but yourself.

—Mennonite proverb

◆

Never go to sleep without considering
how you have spent the day just past and
what you have accomplished for good or evil.

—Mennonite directive

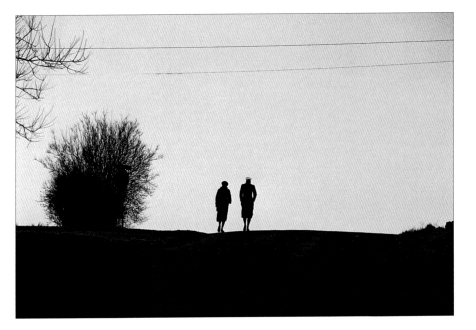

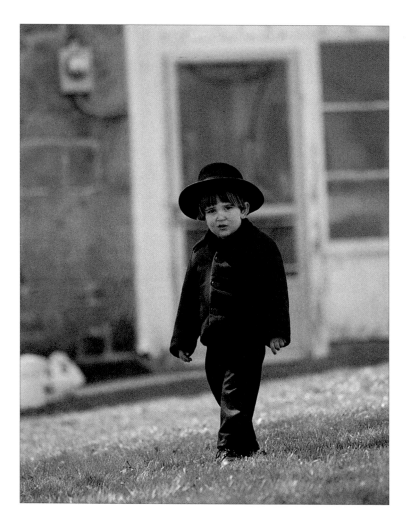

BECKONING TO CHILDREN

Come children learn to fear the Lord
And that your days be long
Let not a false or spiteful word
Be found upon your tongue

—Amish hymn

O happy is the man who hears
the warning voice
And who celestial wisdom makes
His early only choice.

For she has treasures greater far
Than east or west unfold
More precious are her bright rewards
Than gems, or stones of gold

Her right hand offers to the just
Immortal happy days
Her left, imperishable wealth
And heavenly crown displays

As her holy labors rise
So her rewards increase
Her ways are ways of pleasantness
And all her paths are peace.

—*Mennonite song*

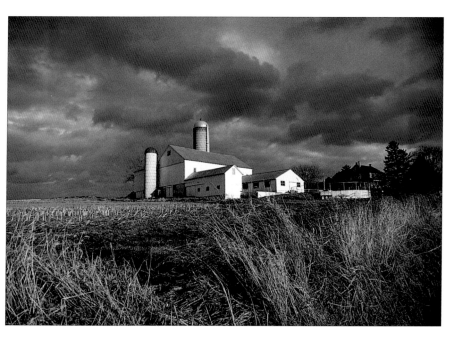

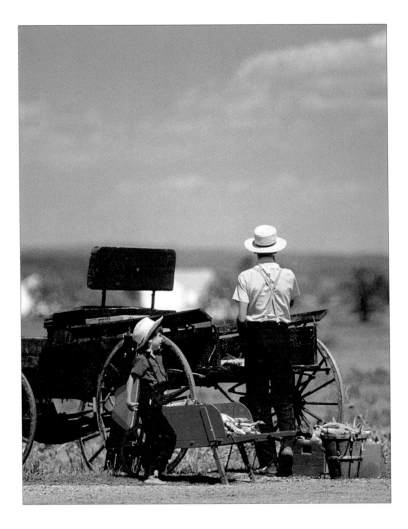

PRAYER FOR VIRTUE

O hasten the hour, send down from above

The spirit of power, of health and of love

Of filial fear, of knowledge and grace

Of wisdom and prayer, of joy and of praise.

—Mennonite prayer

O tell me no more of this world's vain store

The time for such trifles with me is now o'er

A country I've found where joys abound

To dwell I'm determined on that happy ground.

—Amish hymn

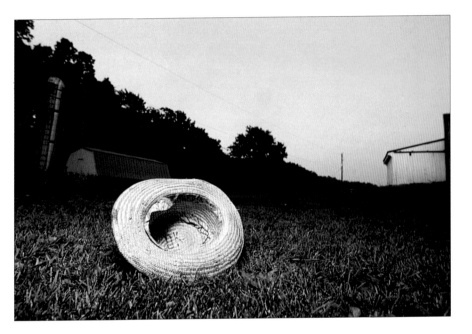

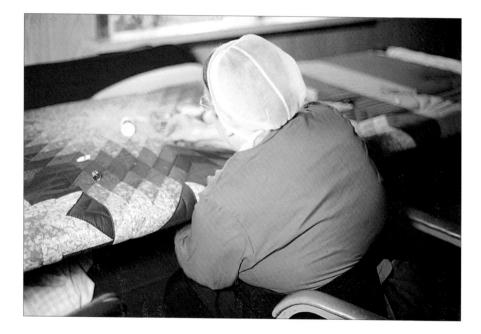

Well begun is half done.

—*Amish woman's proverb*

ON SUNDAY

Sweet is the day of sacred rest
No mortal cares shall seize my breast.

—Mennonite song

◆

MORNING MEDITATION

Dear God, let all my hours be thine
Whilst I enjoy the light
Then shall my sun in smiles decline
And bring a pleasant night.

—Amish prayer

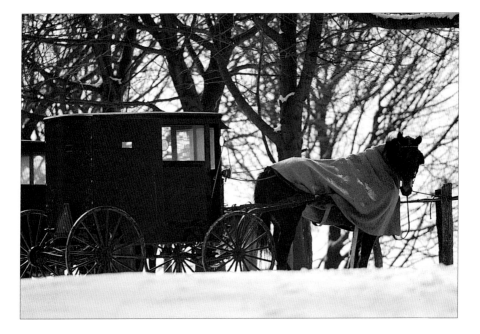

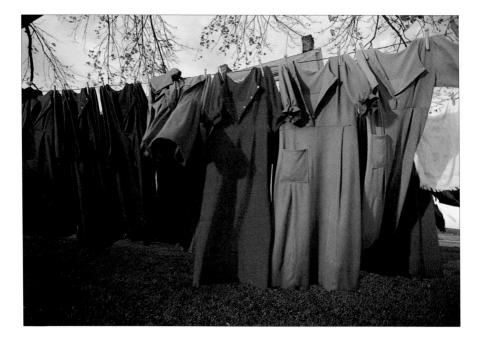

You can't make fine clothes from a coarse cloth.

—*Mennonite woman's proverb*

WISDOM'S WAYS

If our days must fly
We'll keep their end in sight
We'll spend them all in wisdom's ways
And let them speed their flight.

—Amish hymn

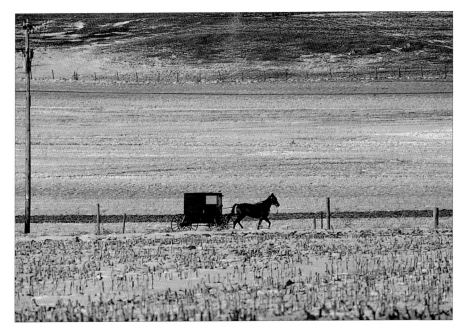

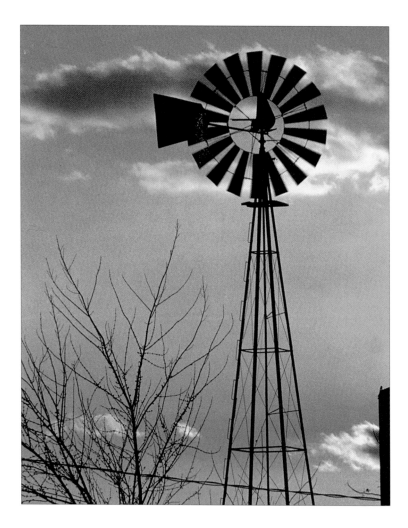

MORNING PRAYER

Let our thoughts, our words and deeds,
ever be pure, kind and good. Let us live peaceably
with each other, respecting one another in love.
Let us see the good in our fellow man, that we
may love our neighbors as ourselves.

—Amish prayer

VANITY'S WAY

How vain are all things here below

How false and yet how fair

Each pleasure has its poison too

And every sweet a snare.

—Mennonite song

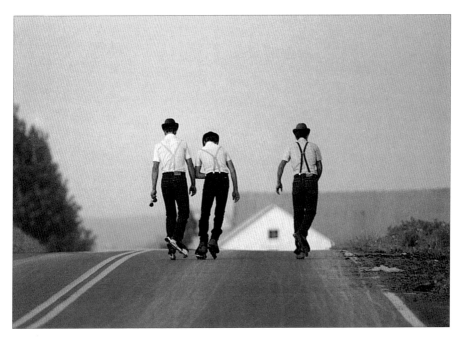

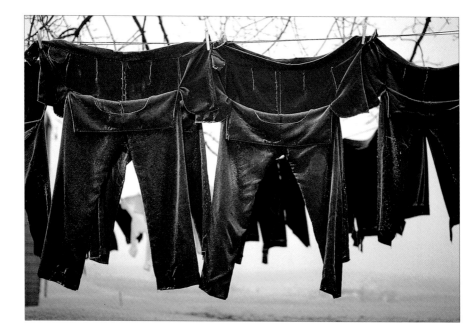

ON THE TRUTH

Wealth we are told is power
and knowledge is power.
But there is a mightier force in this world
than either of these—it is truth.

—Mennonite writings

ON HAPPINESS

Of all classes and descriptions of persons
on this earth, they are the happiest of whom
it may be said that the things most hoped for
by them are the things not seen.

—Mennonite writings

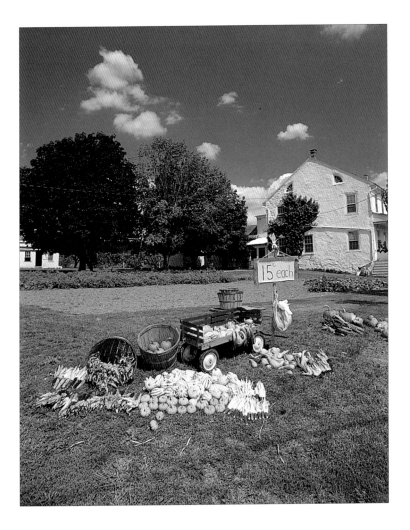

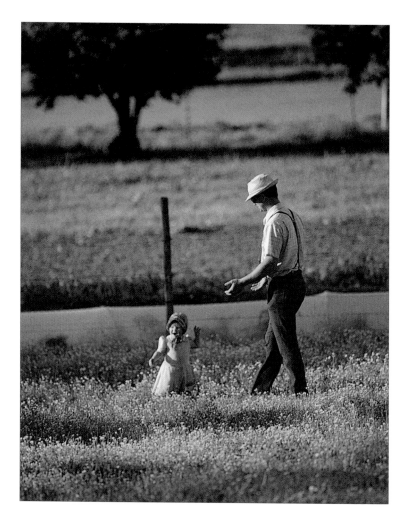

Never let sundown find us with an angry grudge
in our hearts against any.

—*Mennonite proverb*

A CHILD'S PRAYER

Little knees should lowly bend
At the time of prayer
Little thoughts to heav'n ascend
To our Father there.

—Mennonite prayer

◆

They are the children of peace
who have beaten their swords into plowshares
and their spears into pruning hooks
and know of no war.

—Menno Simons

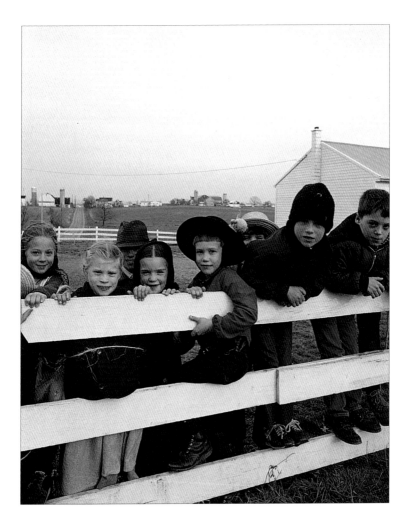

LIFE'S FLEETING WAYS

Today is added to our time

Yet while we pause it glides away

How soon shall we be past our prime

For where, alas, is yesterday?

—Amish hymn

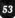

No suffering comes

which is not intended for good.

—*Mennonite woman's proverb*

◆

ON PATIENCE

Nothing teaches patience like a garden.

You may go round and watch

the opening bud from day to day,

but it takes its own time.

—*Mennonite writings*

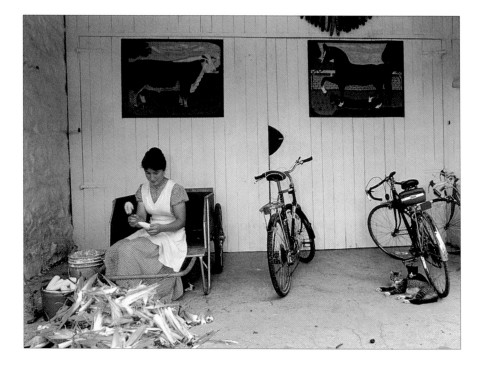

ON HOW TO BE RICH
AND BEAUTIFUL

If any of you are dissatisfied because
you are poor and plain looking,
let me tell you how to be rich and beautiful.
Have a heartful of love and goodness
and a soul beautiful with the beauty
of holiness and you will be rich.

—*Mennonite writings*

How needful then it is
and how willing we should be,
to toil hard day and night
for the treasures of heaven.

—*Mennonite writings*

◆

Never speak evil of any one
on any pretense whatever.

—*Amish farmer's proverb*

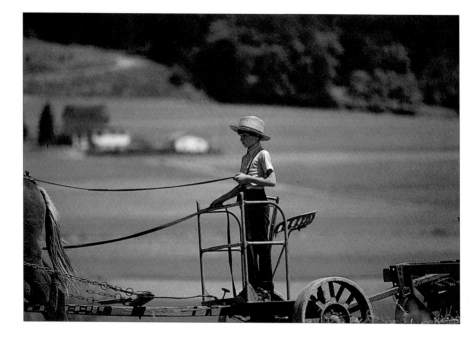

ON INTEGRITY

Adhere most scrupulously to truth
and labor to preserve the strictest integrity,
simplicity and sincerity.

—Mennonite writings

Depart from mischief, practice love

Pursue the works of peace.

—Mennonite song

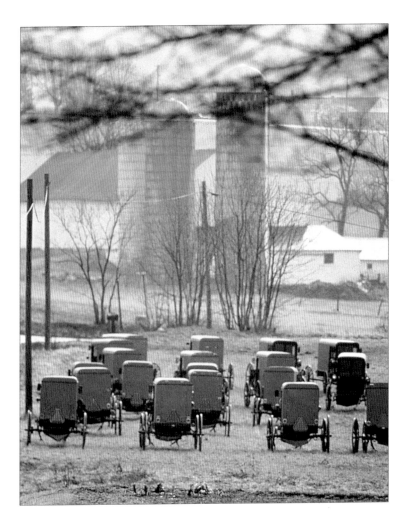

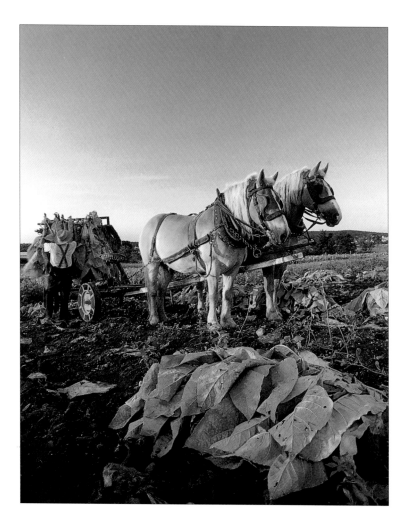

Preside over those in your charge

with kindness and meekness,

rather than subject them to fear and terror.

An oppressor does not rule long.

—Amish proverb

◆

The floweret standing by the path

And brushing 'gainst thy feet

It is, if it doth touch thy heart

From God a greeting sweet

—Mennonite song

From briny seas the sun

Draws only purest waters

May you akin draw love

From hearts of thine own haters

—Amish verse

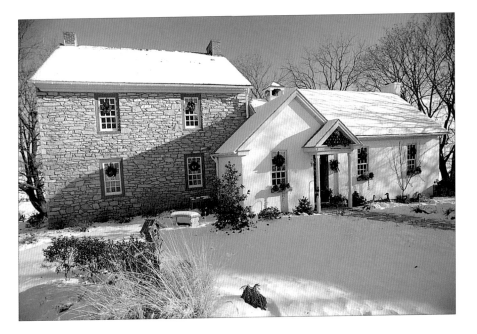

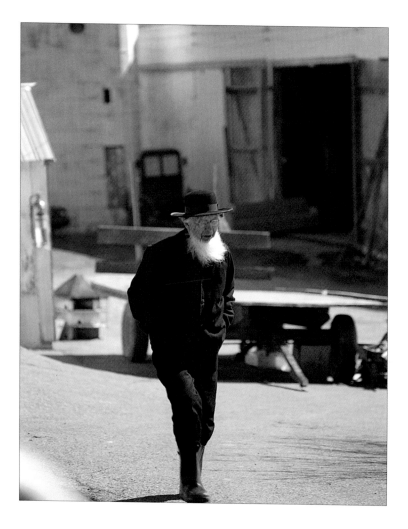

Full wisdom comes at night

For the just closing day

Yet never so wise, quite

As light up morrow's way.

—Mennonite song

To be poor is not disgraceful

but unhandy

—Amish proverb

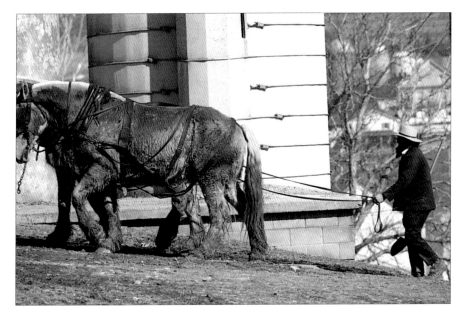

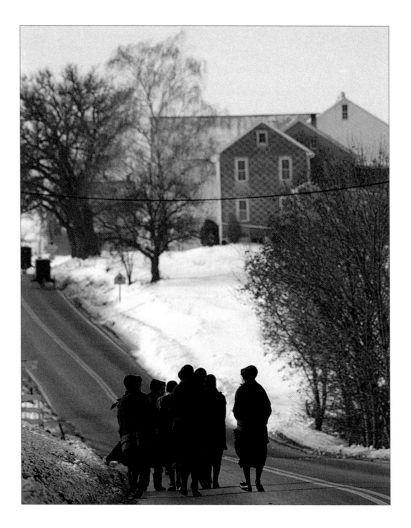

If thou wouldst first thank God

For each good he bestows

Thou couldst not find the time

To murmur of thy woes.

—*Amish verse*

My summer has an end

And mourning I might spend

My autumn days; but happily I know

Beyond this vale of time

A never changing clime

No autumn there, no winter storms blow.

—Amish hymn

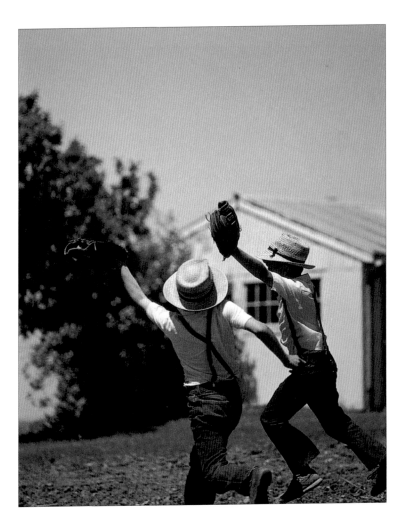

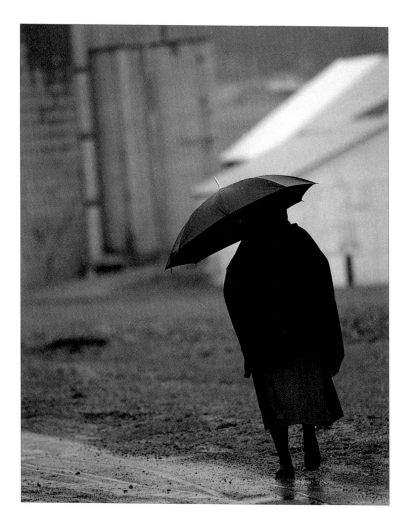

Stay golden hour, oh stay thy fleeting
For ne'er returns so fair a scene
The mellow moonlight's softly sleeping
All around us in silvery sheen.

—Mennonite writings

◆

Burn the candle by day
and you'll have to sit in the dark at night.

—Amish proverb

The time, how lonely and how still

Peace shines and smiles on all below

The plain, the stream, the wood, the hill

All fair with evening's setting glow.

—Amish hymn

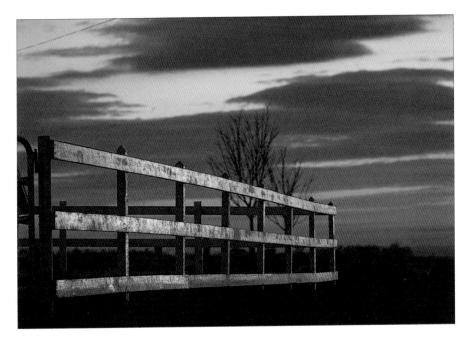

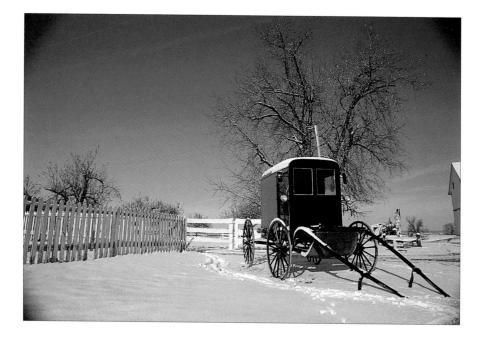

Follow the right.
No matter who you are, what you are,
what your lot or where you live,
you cannot afford to do that which is wrong.
The only way to obtain happiness and pleasure
for yourself is to do the right thing.

—Mennonite directive

◆

If you have an important decision to make,
or you find yourself in circumstances where you
know not what is best to do or answer,
spend at least one night in meditation.
You will not be sorry.

—Amish proverb

Life is onward—never
Look upon the past;
It would hold you ever in its clutches fast.
Life is onward—prize it
In sunshine and in storm
Oh do not despise it
In its humblest form.

—*Mennonite writings*

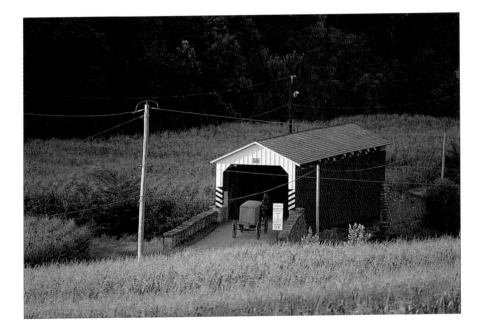

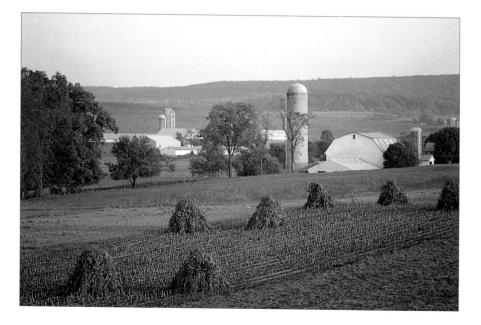

ON TEMPORAL BLESSINGS

Wish for them cautiously

Obtain them honestly

Accept them humbly

Impart them liberally

Resign them willingly.

—Mennonite directive

Be not too ready to believe everything you hear,

and do not repeat everything you hear,

lest in this way you lose a friend

and gain an enemy.

—Amish proverb

◆

Let us take time to be pleasant.

The small courtesies which we often omit

will someday look larger to us than the wealth we

covet or the fame for which we've struggled.

—Mennonite directive

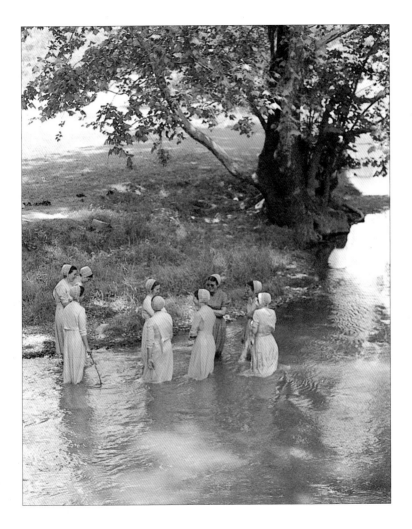

SUGGESTED READING LIST
AND SELECTED BIBLIOGRAPHY

Dyck, C. J. An Introduction to Mennonite History. *Scottsdale, Pa.: Herald Press, 1993.*

Hostetler, John A. Amish Society. *4th ed. Baltimore: The Johns Hopkins University Press, 1993.*

Kraybill, Donald, and Marc A. Olshan, eds. The Amish Struggle with Modernity. *Hanover, N.H.: University Press of New England, 1994.*

MacMaster, Richard K. Land, Piety and Peoplehood. *Scottsdale, Pa.: Herald Press, 1985.*

Scott, Stephen. An Introduction to Old Order and Conservative Mennonite Groups. *People's Place #12. Intercourse, Pa.: Good Books, 1996.*